"One of the most meticulous concrete poet[s] with his new book *Inherent*, revivifies the topography of typographic poetics, giving it a bold new visage. With a designer's discernment and a poet's heart, Stebner attunes himself to the murmurs of each typeface, liberating each and every one from language's limits to vibrate in constellations of their own truth and beauty."—Eric Schmaltz, author of *Surfaces*

"The poem-texts in *Inherent* explore/exploit the territory between glyph and word, letter and semantic value, demonstrating the power of the sub-atomic level of language in its capacity to act provocatively through the eye to mind with resonant sound-sense. The typographic richness of unusual fonts positioned dynamically on the page is a great reminder of how much freedom there was in dry lettering (aka Letraset) technology. Every move, every placement, was a deliberate act contributing to the construction of a text. These works shimmer, shake, and vibrate with excitement in an architectonic zone of imaginative composition."—Johanna Drucker, author of *Inventing the Alphabet: The Origins of Letters from Antiquity to the Present*

"This is work of virtuoso beauty made by a master spinner of signs: crystalline, multi-faceted kaleidoscopic letterforms, mazes, roadmaps, blueprints, mandalas, I-think-knots, sometimes playful, sometimes numinous, alien, human, tactile with craquelure, synaptic as neural networks, lyrical, jazzy, magical, elegant. Stebner's eyemusic made with dry transfer typefaces shows that letters are the ultimate building set as he sings infinite signifiers, sigils, and symmetrical signals. The endless sighs and size of the designs insightfully show that language is the most fun one can have looking at thinking and thinking about looking."—Gary Barwin, author of *For It Is a Pleasure and a Surprise to Breathe: New and Selected Poems*

"Kevin Stebner's *Inherent* is a bold library of shape-shifting concrete poems. Every page reveals a typographical surprise. Stebner's language becomes a material entity that marches its way through as the book progresses: letters dance, huddle and disperse, and point to the visual charm of language itself. This is a must for Letraset lovers and everyone interested in visual play!"
—Astra Papachristodoulou, author of *Constellations*

inherent

KEVIN STEBNER

Assembly Press

Prince Edward County, Ontario

Library and Archives Canada Cataloguing in Publication

Title: Inherent / Kevin Stebner.
Names: Stebner, Kevin, author
Identifiers: Canadiana (print) 2024043319X | Canadiana (ebook) 20240433211 |
ISBN 9781738009848 (softcover) | ISBN 9781738009855 (PDF)
Subjects: LCGFT: Concrete poetry.
Classification: LCC PS8637.T39 I54 2024 | DDC C811/.6—dc233

Published by Assembly Press | assemblypress.ca
Cover and interior designed by Greg Tabor
Edited by Derek Beaulieu

Printed and bound in Canada on uncoated paper made from 100% recycled content in line with our commitment to ethical business practices and sustainability.

Contents

ultimatum

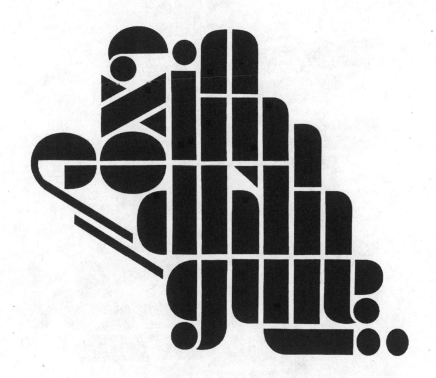

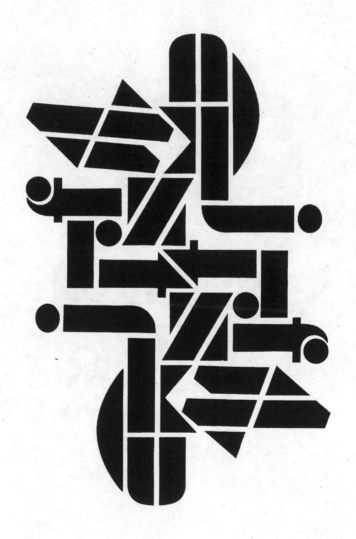

4

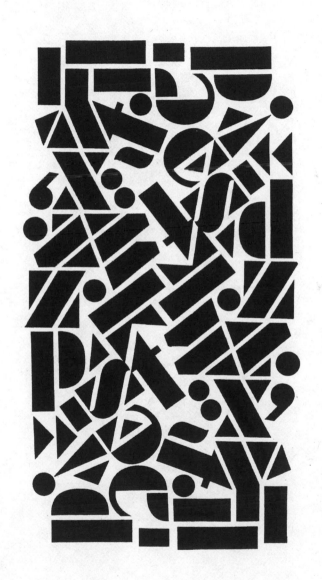

5

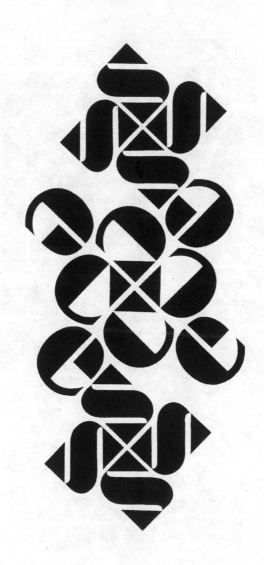

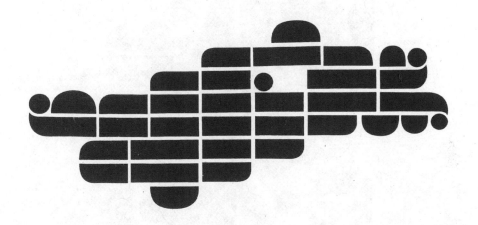

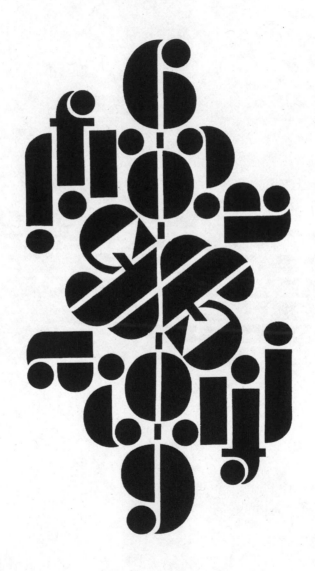

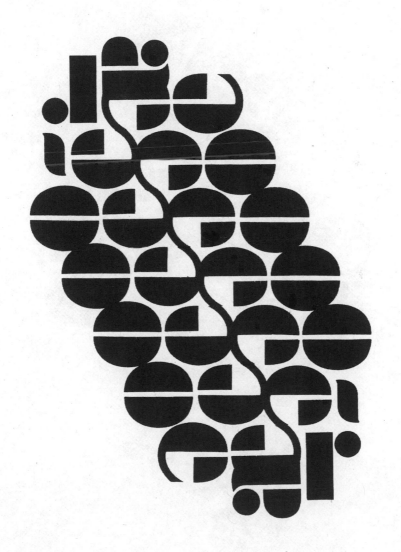

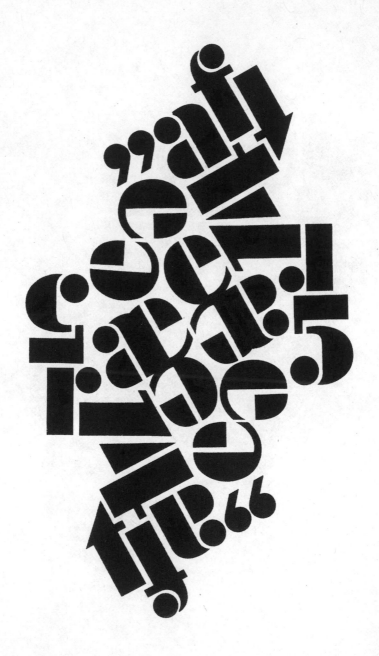

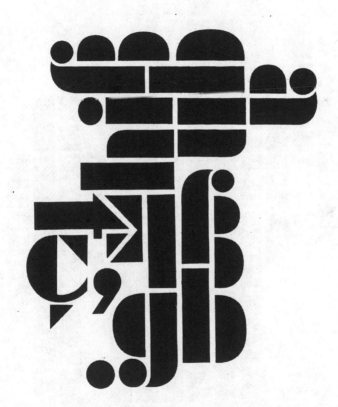

11

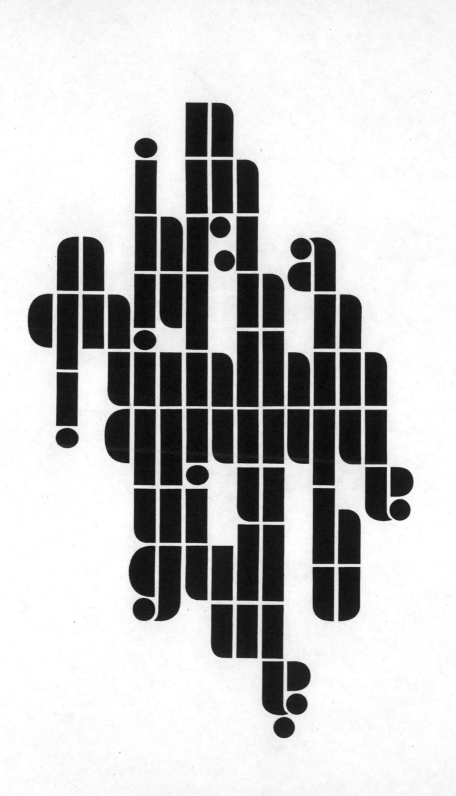

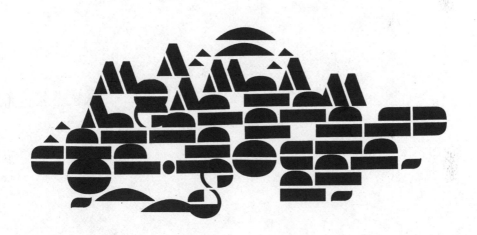

Adieu Adieu

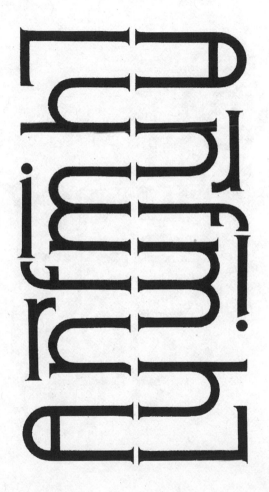

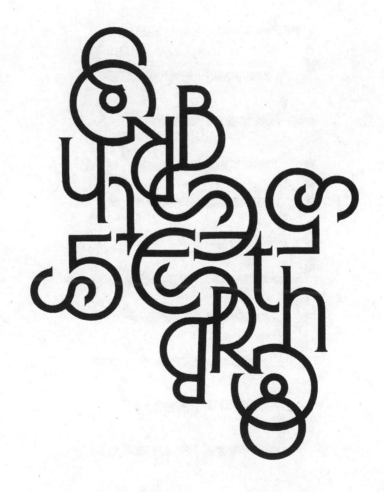

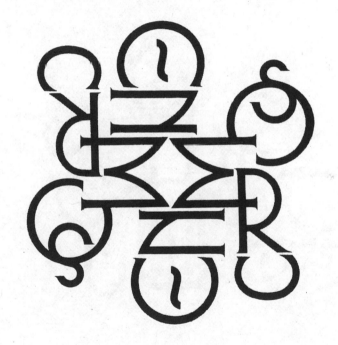

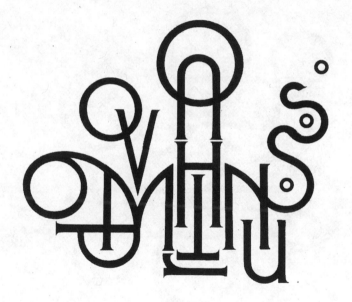

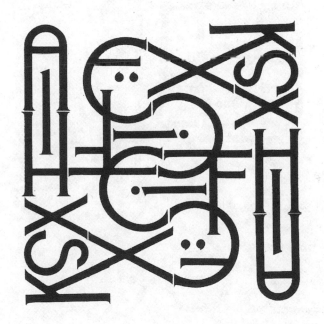

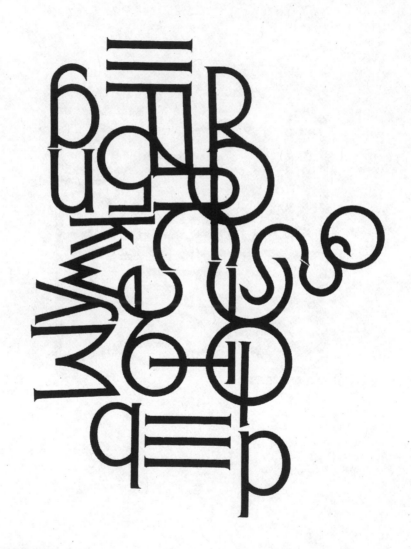

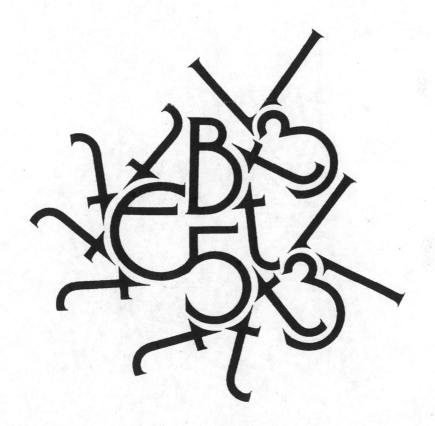

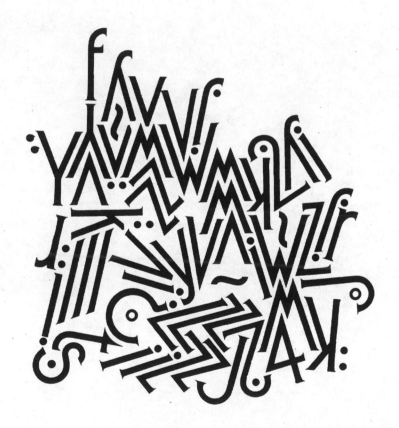

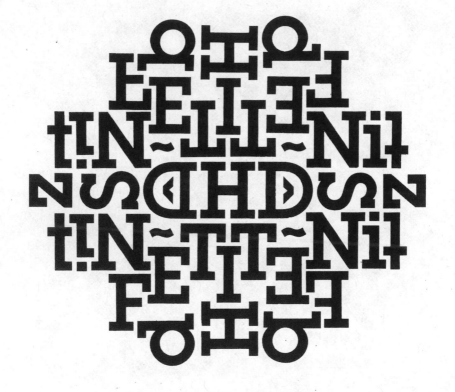

28

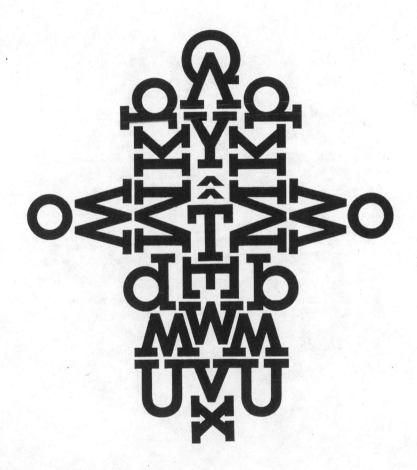

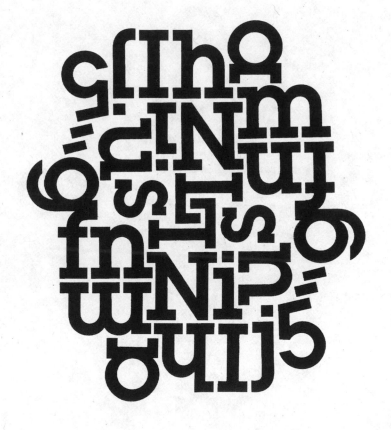

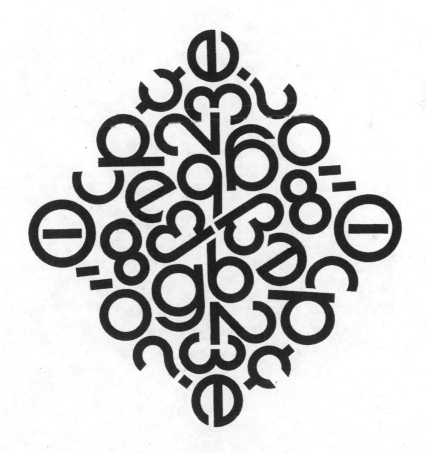

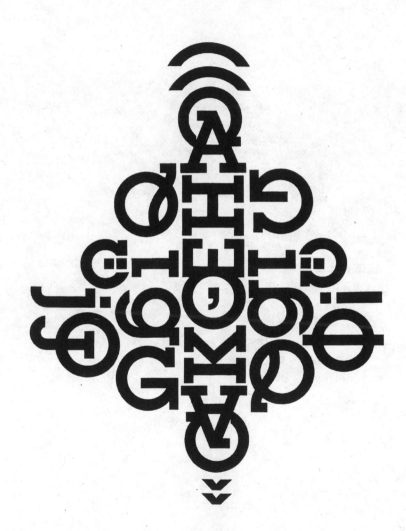

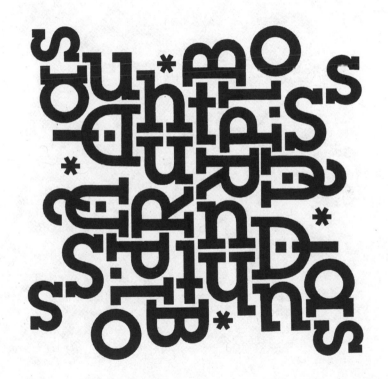

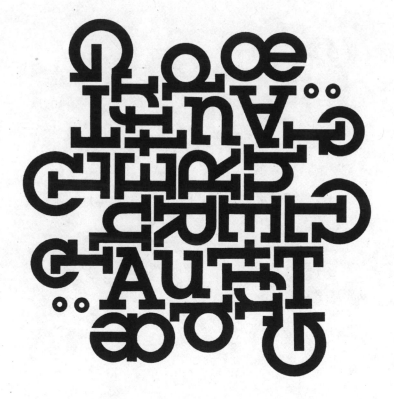

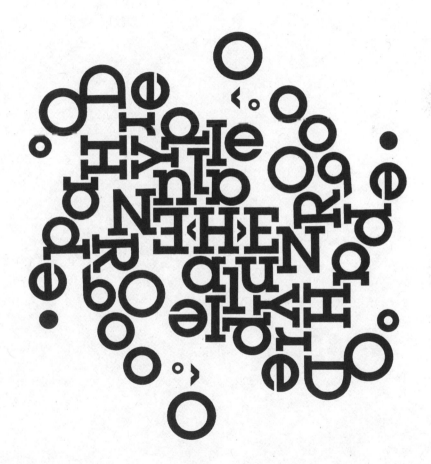

agalma

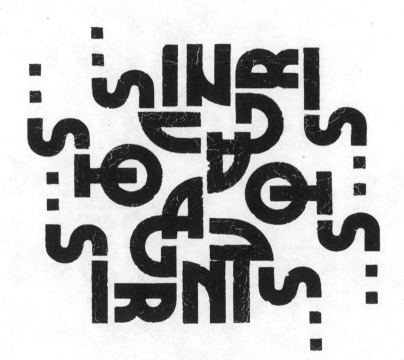

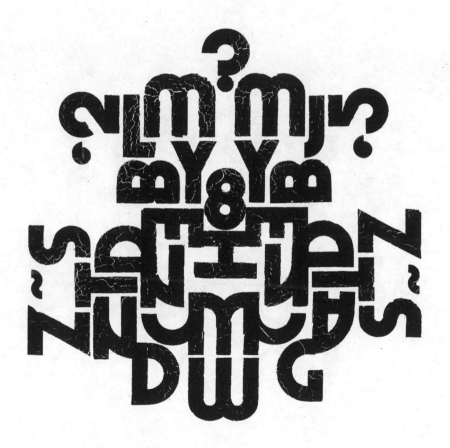

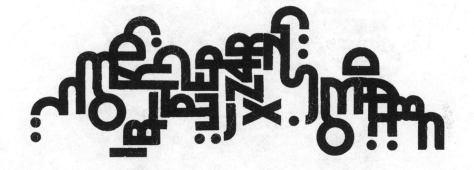

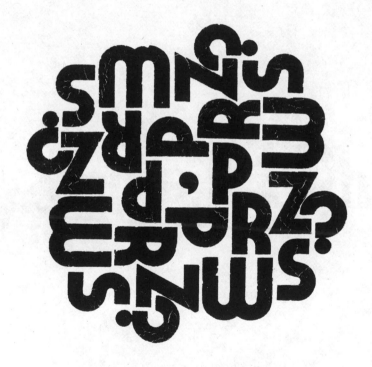

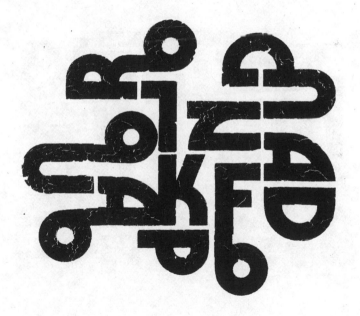

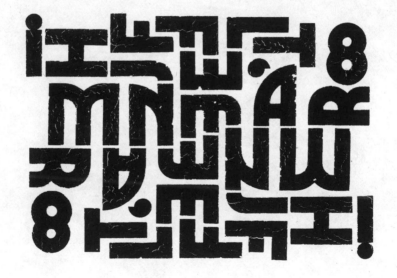

46

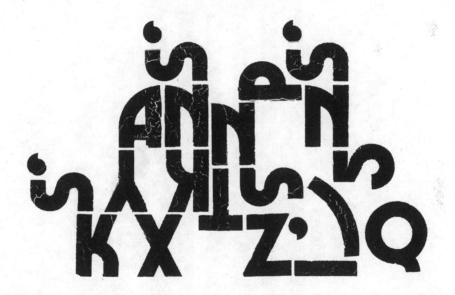

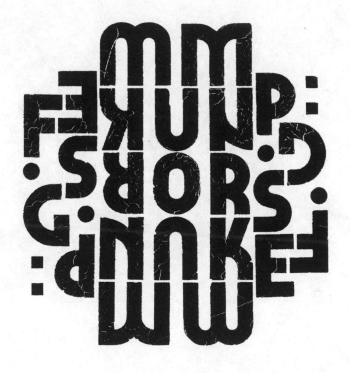

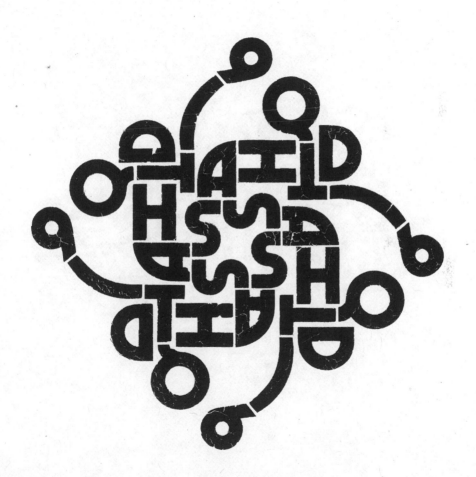

49

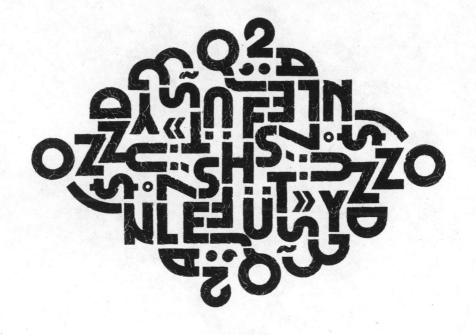

significant

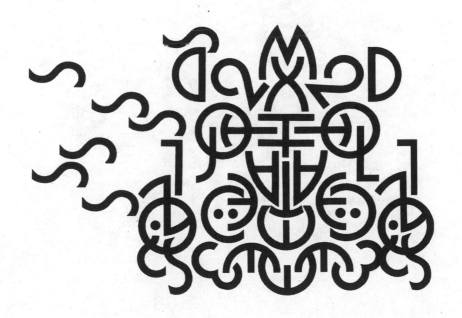

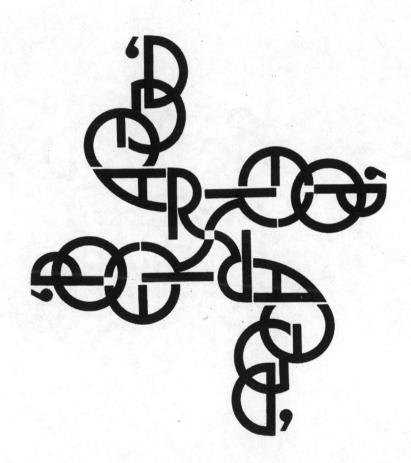

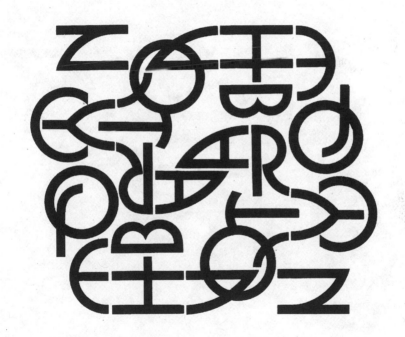

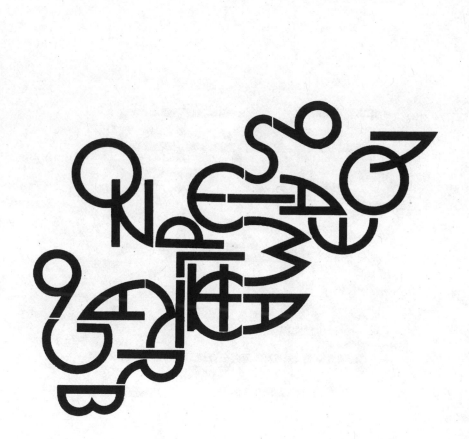

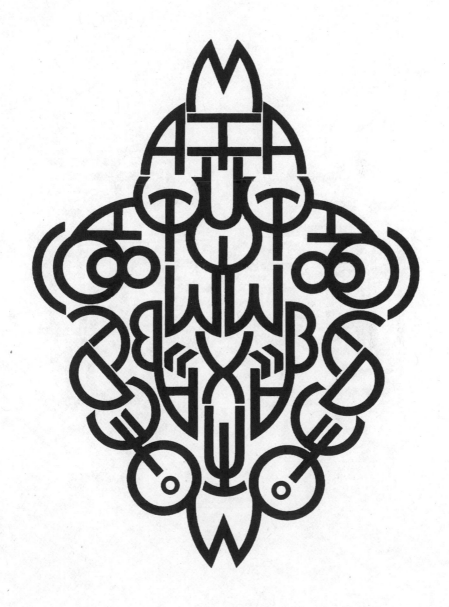

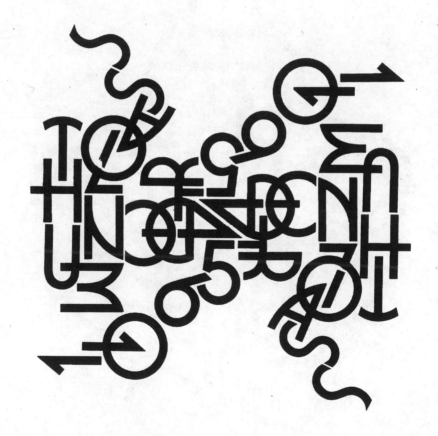

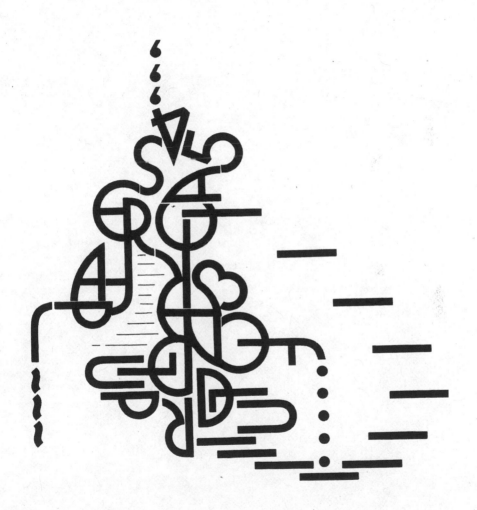

süpeRiör

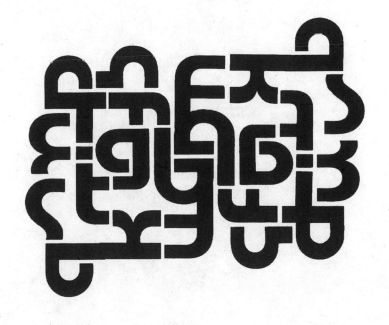

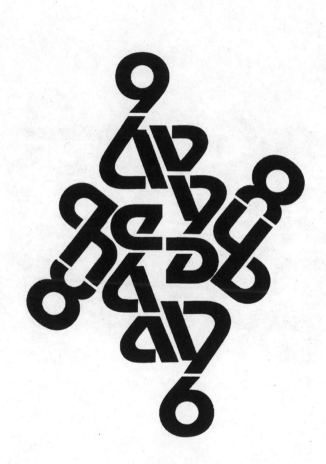

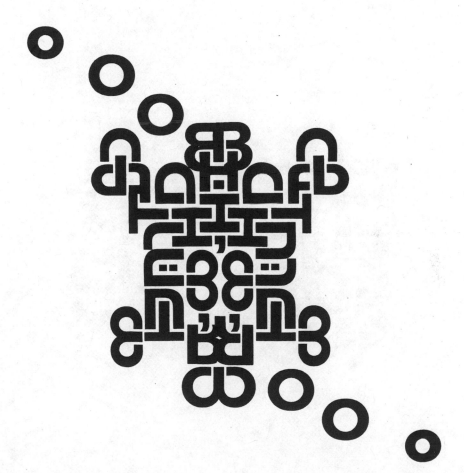

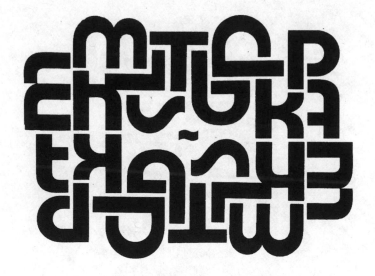

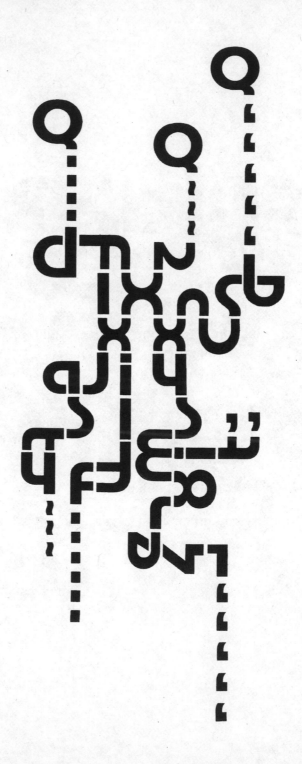

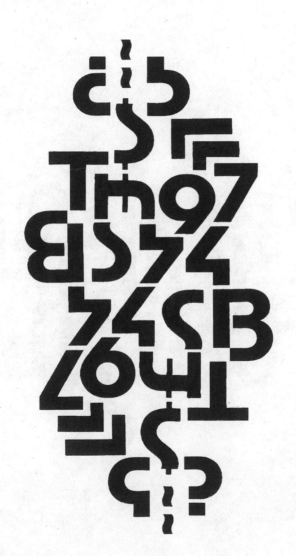

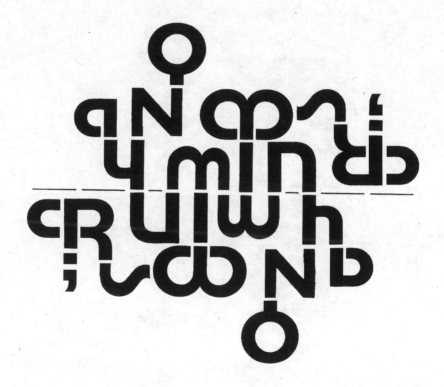

Peaceful

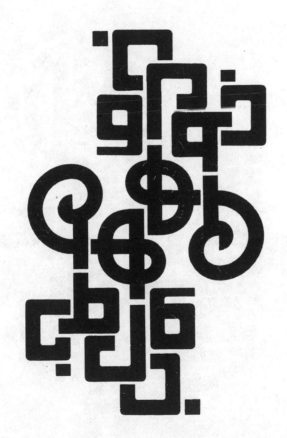

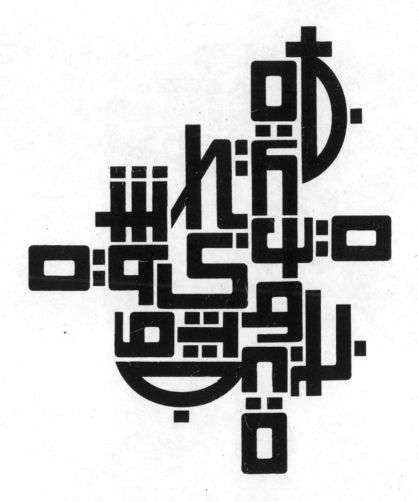

74

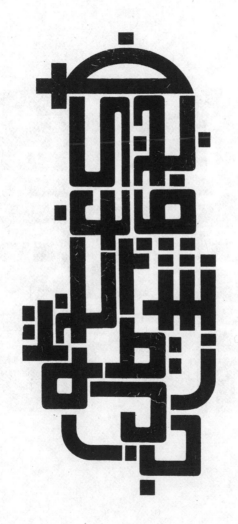

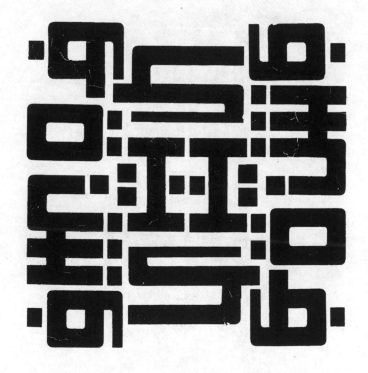

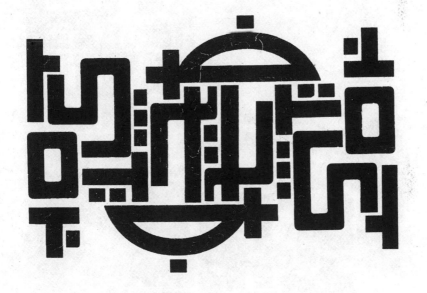

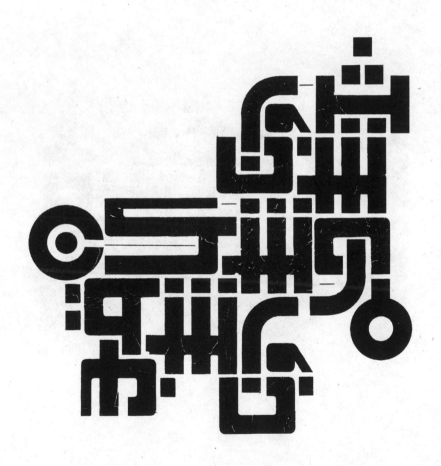

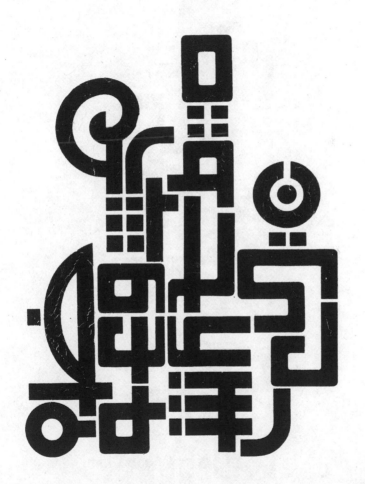

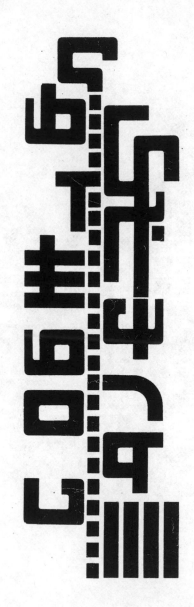

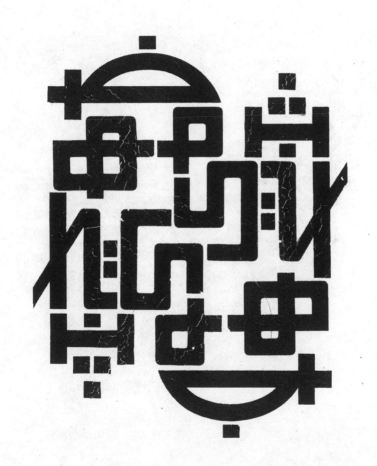

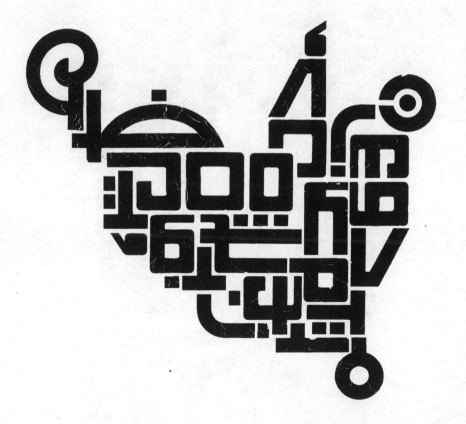

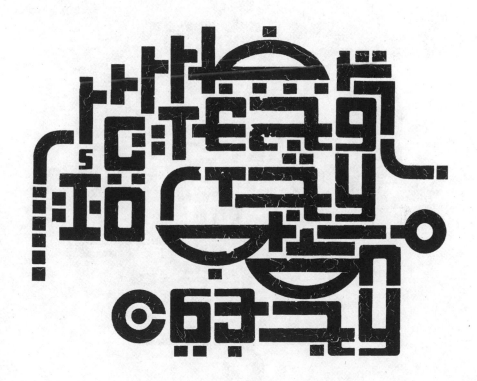

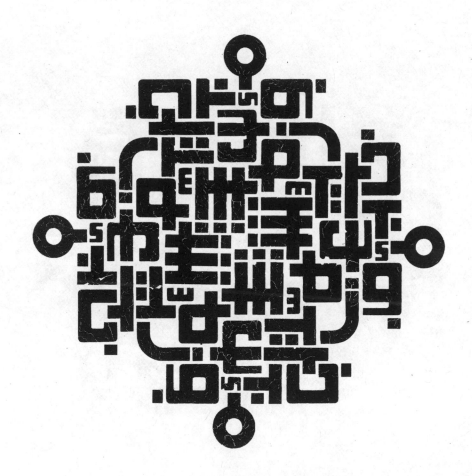

bréthrèn

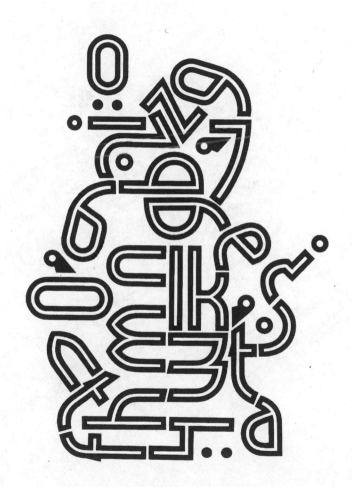

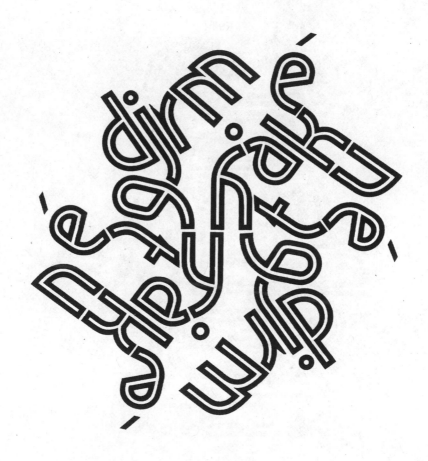

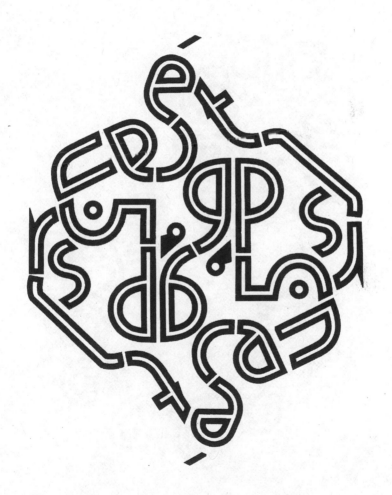

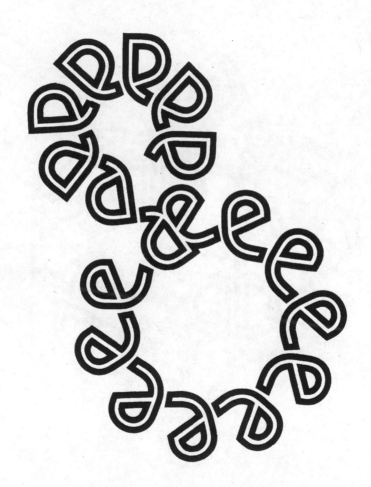

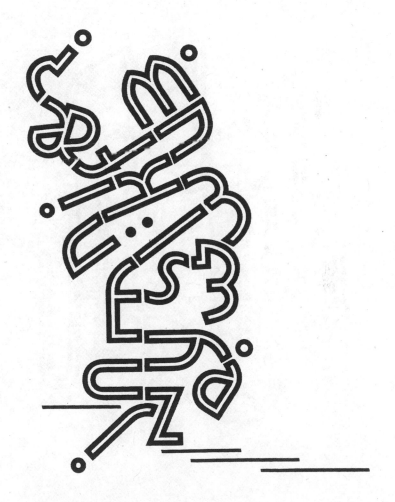

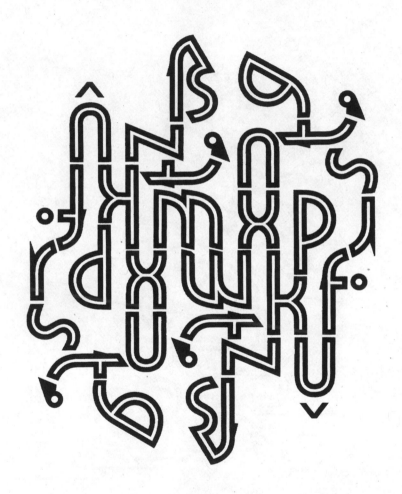

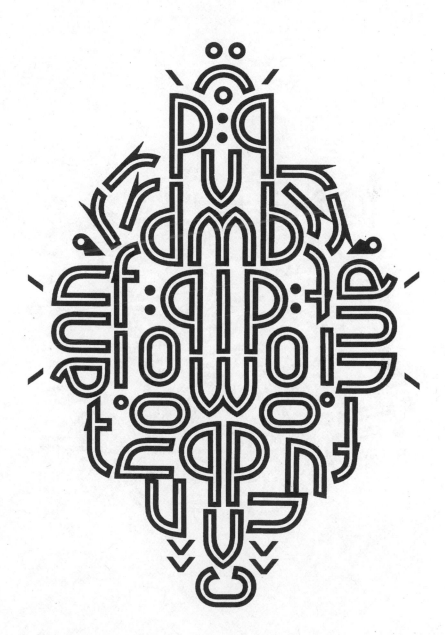

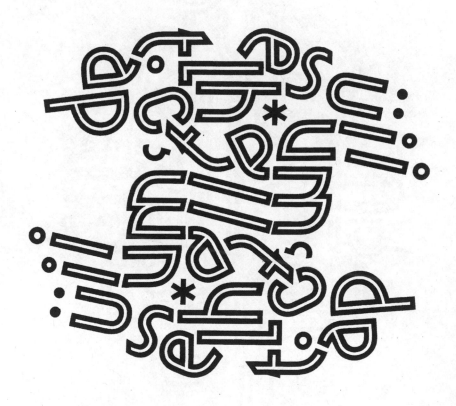

assemblage

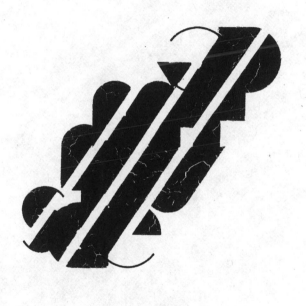

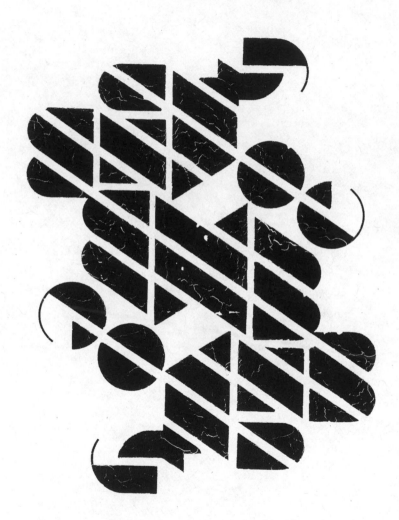

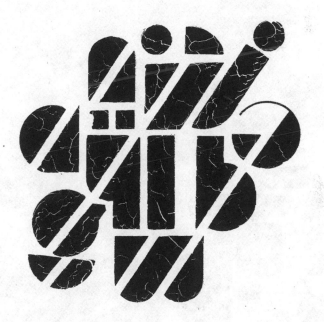

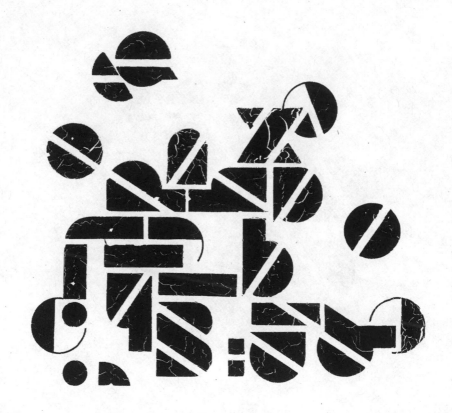

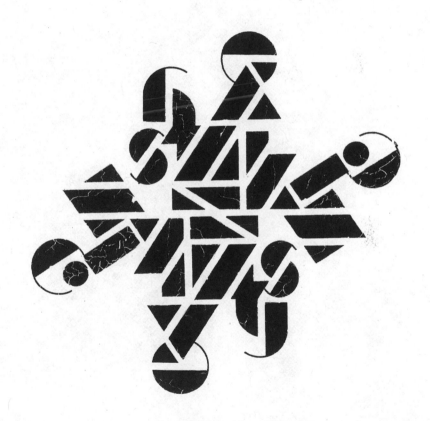

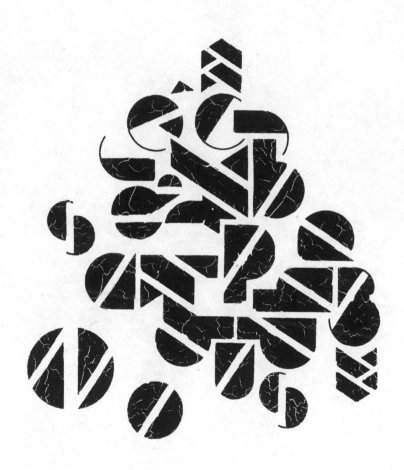

PRESENT

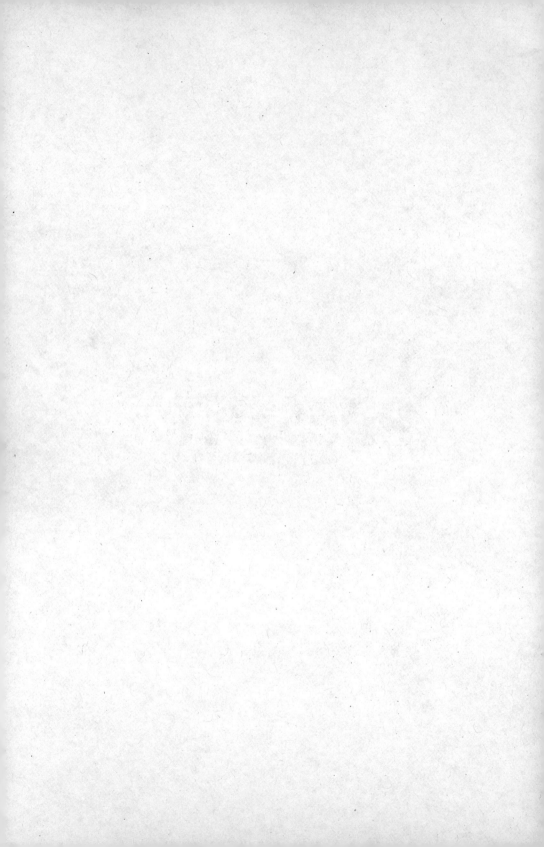

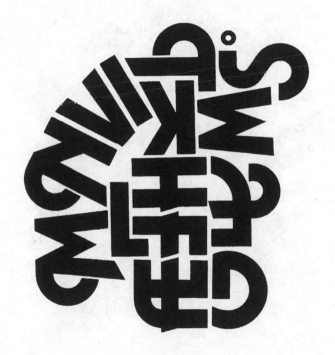

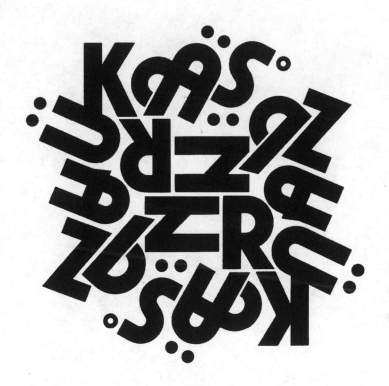

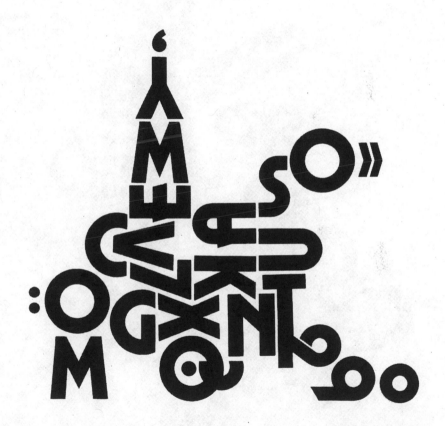

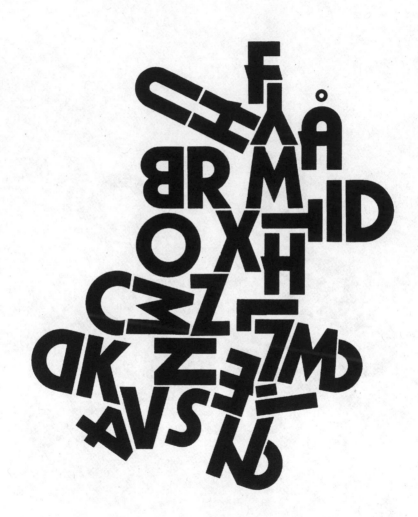

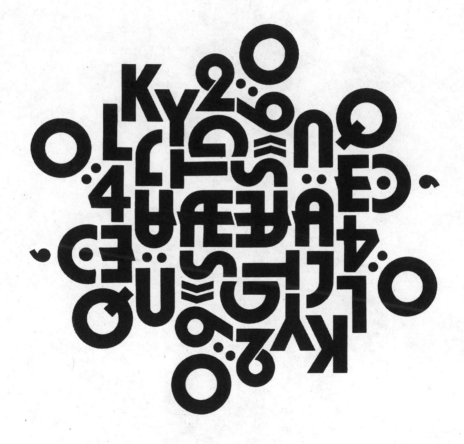

KINDLED

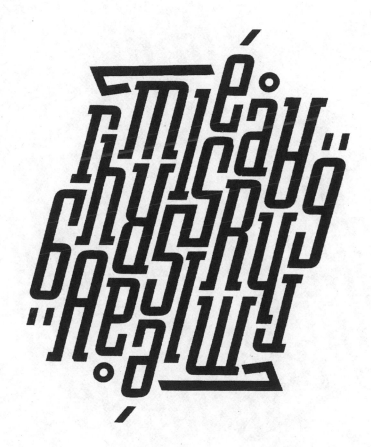

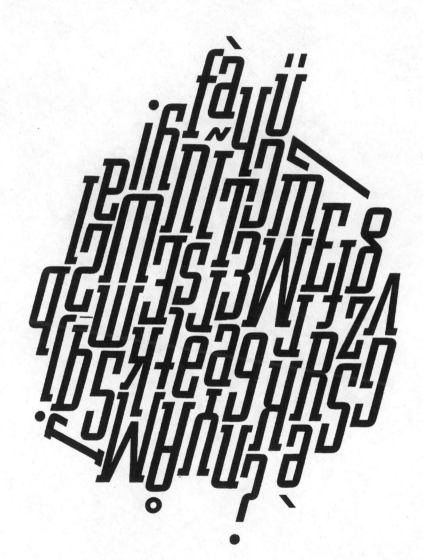

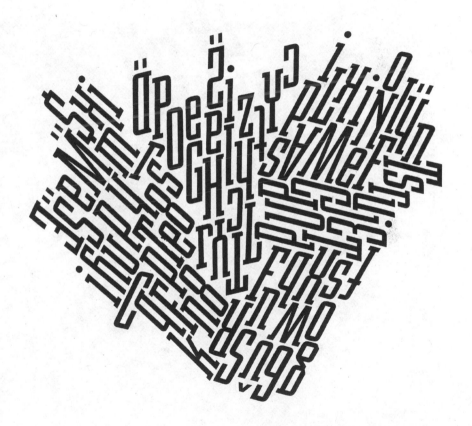

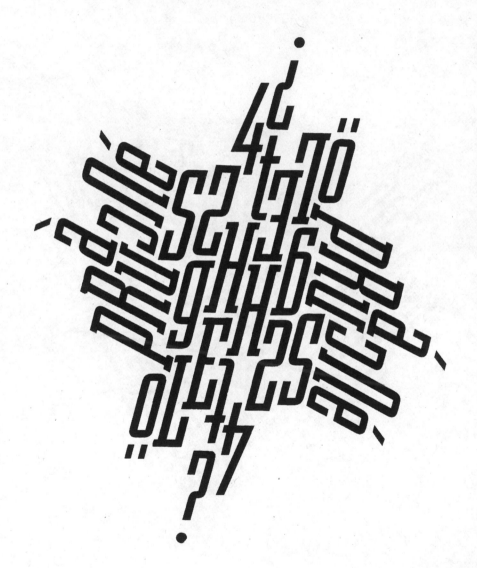

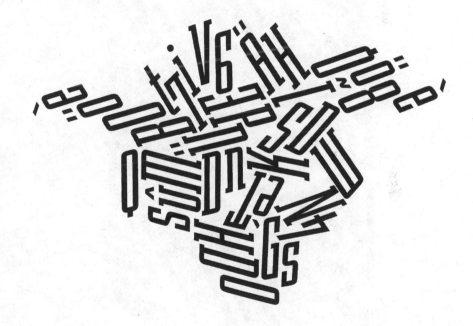

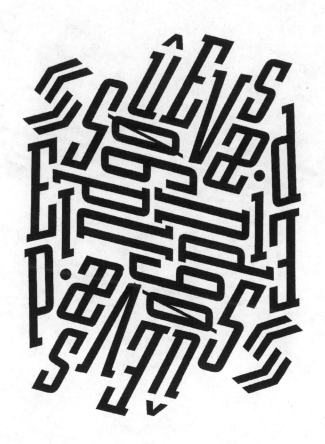

Unbroke

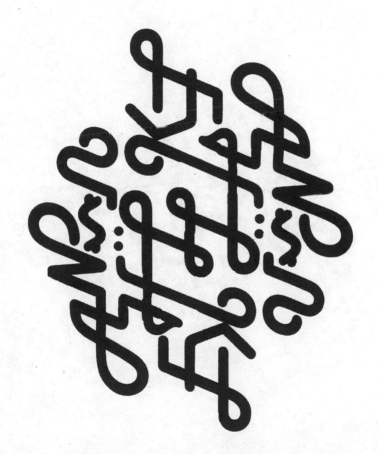

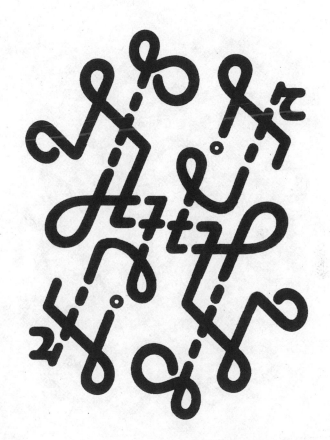

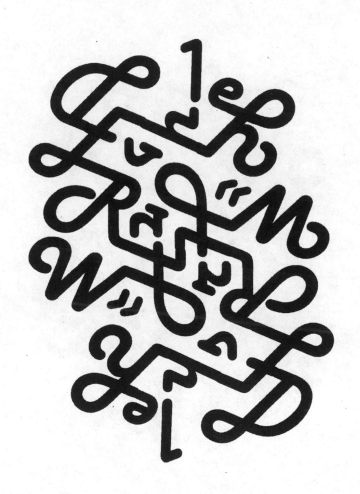

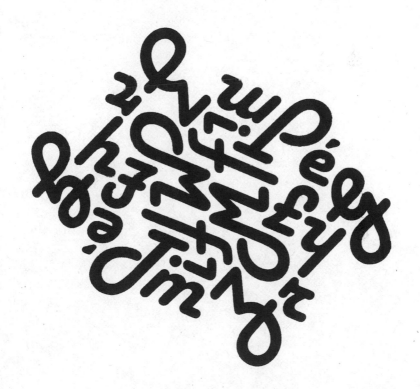

Well Worn

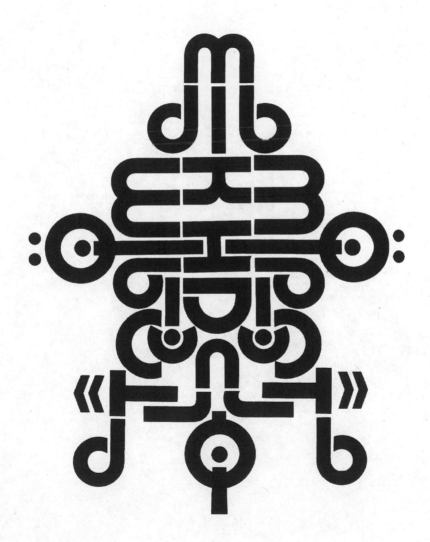

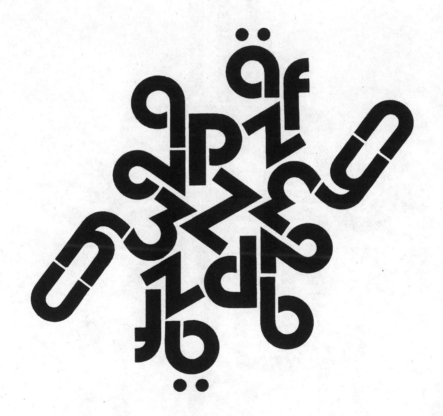

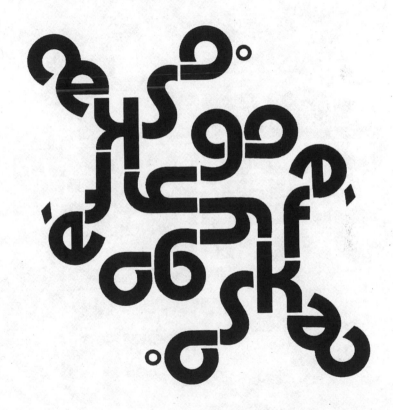

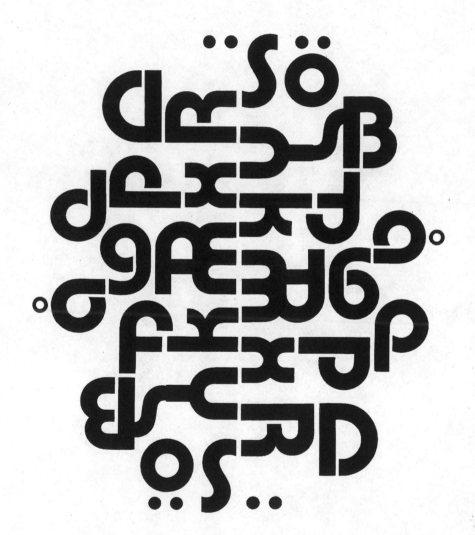

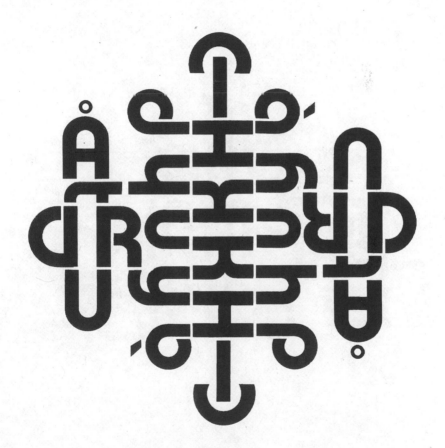

133

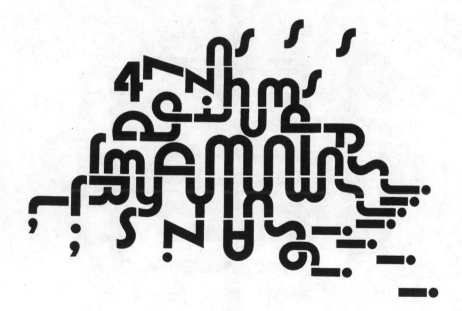

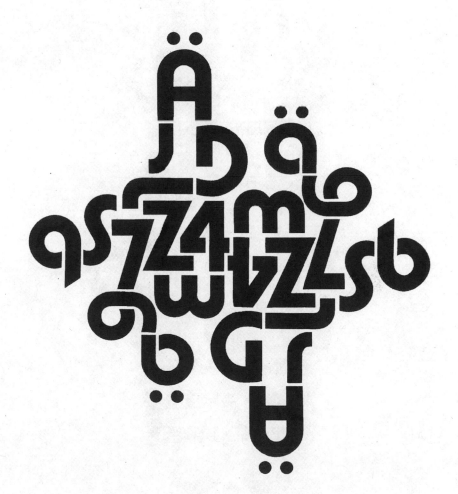

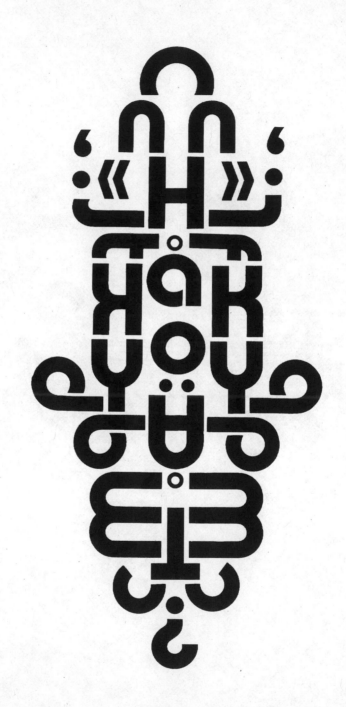

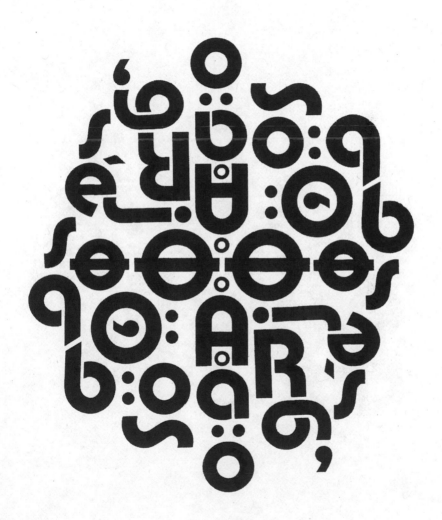

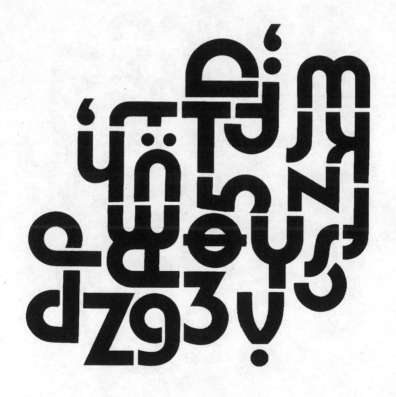

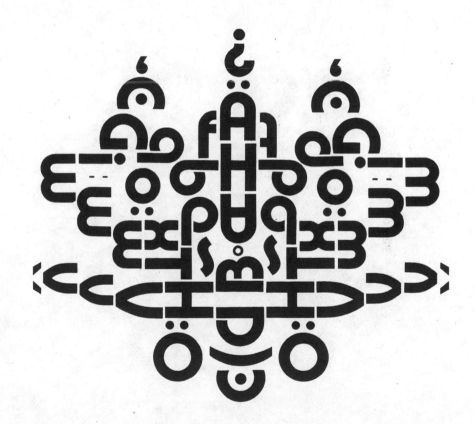

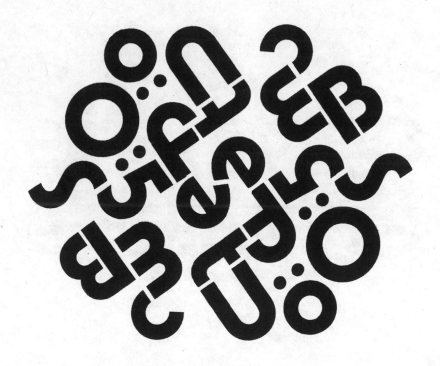

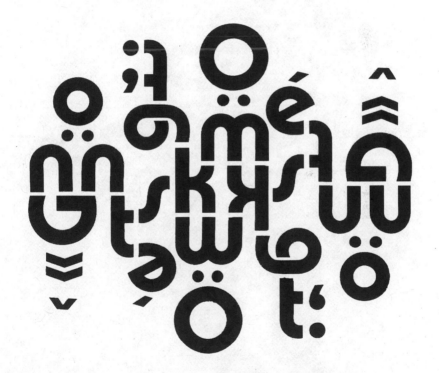

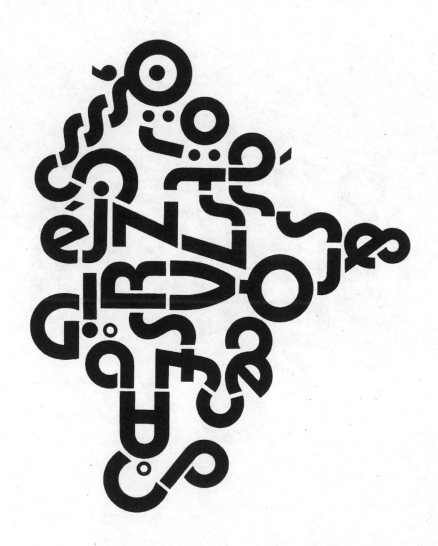

Explication

Typefaces have personality built into their forms. Graphic designers come to know the voices of certain typefaces, and as a daily consumer of texts, you probably have an innate sense of the personalities of common typefaces too. Take the much-maligned Comic Sans, for instance: there is an intrinsic understanding that it's not suited to formality. Comic Sans has a function, one that simply will not work on ambulances or funeral home signage. Whereas Times New Roman was created for legibility in newspapers, and Helvetica's voice disappears into its unassuming ubiquity—it's used by everyone from Panasonic and Microsoft to Lufthansa and American Airlines, American Apparel, on Canadian roadside signage, and on and on.

In creating *Inherent*, I respond to the vibe of each typeface itself, trying to demonstrate how these typefaces would speak without the constraints of human language and if they weren't forced into the hard linearity of how words appear on the page. As both readers and writers, we are so often stuck to the flagpole of the left margin, to strict semantic meaning, biases of words, end rhyme, and conventions of language. Instead, I am interested in how a typeface would wish to express itself if given the freedom to do so. I want to let the letter forms move how they will and show us their voices separate from human language. I am seeking to find what is inherent within the typeface, and what aspects of form and design will lead to a typeface's own poetic stance. What is innate in a letter form? What does it want to express? I have forgone my own authorial hand to try less at expressing an exacting statement and to allow that punctum to arise from the letter forms themselves.

A great deal of my literary explorations arise out of "dated" technology—I've used typewriters as dimensional machines, and Game Genies or arcade machines as poetic canvases. While some see new technology as the force that pushes literature into uncharted waters, my own experience with newer digital realms has left me frustrated. There's a certain loss of physicality in digital applications, in over-familiarity through the daily use of computers and phones and the stricture of digital tools. I feel a disconnect working with a mouse and keyboard, and therefore limited in the ways I can work with language and text. I find that "dated" techniques and tools give me the most leeway as a builder and constructor of poems. Without computer mediation, I have become closer to letter forms and understand their workings a little better.

The poems in this book were "written" by hand using sheets of dry transfer lettering. Dry transfer lettering was a graphic design tool used in a pre-computer world. Produced by a number of companies, it is commonly referred to by the name of the largest manufacturer: Letraset. It is the format of Letraset itself—the physical manipulation, the tangible transference, the irrevocable choice—that has allowed these poems to form. This is a poetry of format. Through the act of physically scraping each letter onto the page, letters can be seen for their structural components, and their unique personalities become a little clearer. A collection of letters within a typeface may work together and speak with a unique voice. I have come to know these letter forms quite well, and I hope I have been an adequate conduit and constructor for their messages. They move with palindromic rotational symmetry into arrays of potential landscapes, and in some cases evolve into alien languages where the Roman alphabet disappears altogether. Inherent voices are at work here—what do these poems say to you?

Acknowledgements

Selections from *Inherent* have previously seen life in journals and chapbooks:

Two selections from "Ultramatum" appeared in *The Minute Review* Vol. 2 No. 8.
Selections from "Totemic" and "Ultramatum" were published as *TOTEMIC* (No Press, 2023)
"Significant" as a whole was published as *Significant* (No Press, 2023)
Selections from "Agalma," "Ultramatum" and "AdieuAdo" published as *Agalma* (above/ground, 2023)
"Peaceful" as a whole was published as *Peaceful* (Blasted Tree, 2023)

Major thank yous to Andrew, Leigh, and Debby from Assembly Press for all their efforts bringing this book into the world and for instilling their belief in my work. Thanks to derek beaulieu for his huge support and guidance in pursuing this concrete poetic work, and his ongoing help in making this book come to life. Thanks to Kyle Flemmer and the rest of the Blasted Tree associates for their support and activity. Thanks to the scrapbooking community on Etsy, and my collector scum friends along the way, for assisting me to acquire these weird Letraset sheets. Thanks to my husband, Joe, for letting me spread those all over the dining room table. Huge love and thank yous to those presses supporting and promoting concrete poetry, DIY, and weirdness the world over.

Kevin Stebner is an artist, poet and musician. He produces visual art using old videogame gear and produces music and soundtracking with his chiptune project GreyScreen, post-hardcore in his band Fulfilment, as well as alt-country in the band Cold Water. Stebner has published a number of typewriter visual poems and other concrete work in chapbooks. He is also the proprietor of Calgary's best bookstore that's in a shed, Shed Books. Stebner lives in Calgary, Alberta.